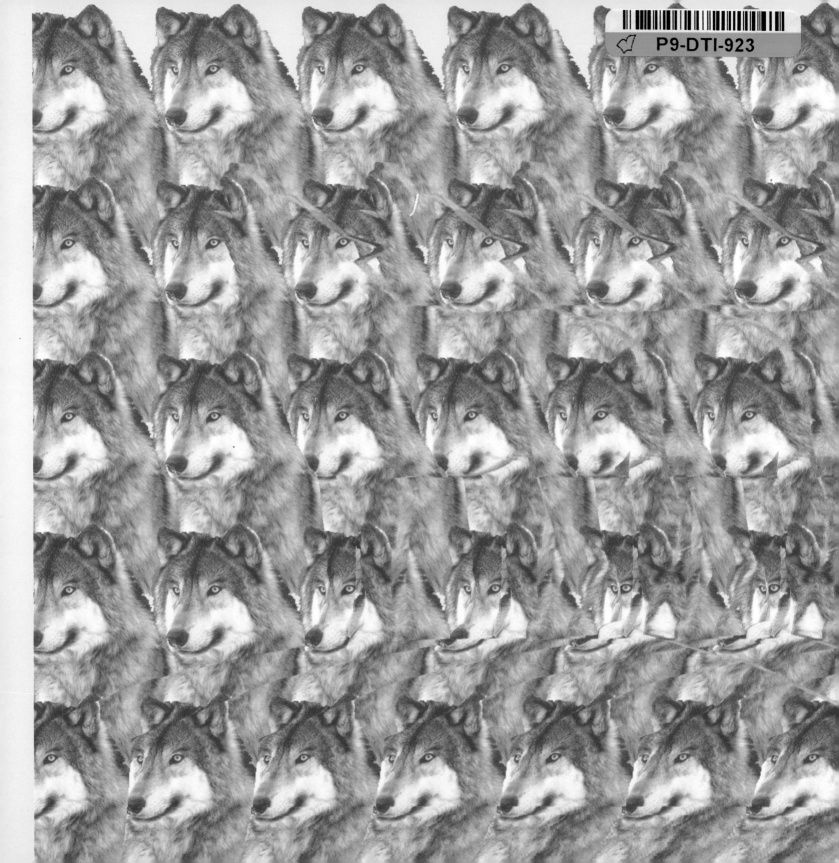

# How to See the Hidden 5-D™ Stereogram Image

Hold the art close to your nose so that it appears blurry. Relax your eyes and stare at the artwork. Make believe you are looking "through" the art. Slowly move the artwork away from your face until the hidden Multi-Dimensional image resolves into perfect clarity. The time It takes to see the image can vary, so don't get discouraged!

Alternate viewing method: Place a sheet of plastic or glass over the page so that you can see your own reflection. Hold the art at arm's length and focus on your reflection in the plastic or glass until the 5-D™ stereogram image resolves into perfect clarity.

If you are still unable to see the images, pictures of the hidden 5-D™ stereogram images can be found at the end of this book.

Important: If you experience any discomfort, stop, rest, and try again later.

# Endangered Species in 5-D™ Stereograms

Created by Stephen Schutz, Ph.D.,
and Susan Polis Schutz

Every illustration in this book
has a hidden 5-D™ stereogram picture
waiting to be discovered by you.

**Blue Mountain Press** ®

Boulder, Colorado

Five percent of the proceeds from the sale of
this book is being donated to a non-profit
organization for the conservation of wildlife.

This book is printed on recycled paper

Mail Order

Most of the 5-D™ stereograms published in this book are available on greeting cards, prints, and calendars.

Due to the enormous popularity of Blue Mountain Press' products, you may find that your local stores are temporarily out of the designs you desire.  If this should happen, we welcome your mail-order inquiries.

Write to us for information:

Blue Mountain Press
Mail Order
P.O. Box 4549
Boulder, CO 80306
(303) 449-0536

The following people are to be thanked for their valuable contribution to this book: Faith Gowan, Jody Kauflin, Norine Neely, Jan Betts, Doug Pagels, John Crane, Patty Brown, Ed Guzik, Mark Rinella, Matt Rantanen, Jared Schutz, and Adam Tow.

Photo of Sumatran tigers in the 5-D™ stereogram "On the Brink of Extinction" taken at the San Diego Zoo. Special thanks to John Turner and the Tiger River Team.

Note: Most, but not all, of the animals depicted in the 5-D™ stereogram "Planet Earth" are considered to be endangered or threatened.

▟ design on book cover is registered in U.S. Patent and Trademark Office

ISBN: 0-88396-393-0

Printed in Hong Kong
First Printing: July, 1994

**Blue Mountain Press** ®
P.O. Box 4549, Boulder, Colorado 80306

"One touch of nature makes the whole world kin"

— William Shakespeare, 1601

# Introduction

**Endangered Species in 5-D™ Stereograms** presents wildlife as you have never seen it before. The famous artist (and physicist) Stephen Schutz, Ph.D., demonstrates a new level of ingenuity by applying his exciting 5-D™ stereogram technique to create realistic, hidden Multi-Dimensional animals in their natural habitats.

As you gaze upon these incredible representations of our kin, remember that every one of these species is directly threatened by the actions of humans. Furthermore, the health of each of these endangered animals serves as an indicator for the well-being of the ecosystem in which it lives. The extinction of one of these species may well mark the loss of many other animals making use of the same habitat.

Twenty years ago species were becoming extinct at a rate of almost one per day; today species disappear at the rate of nearly one each hour. If current trends continue, a fifth or more of all species of plants and animals could disappear or be doomed to extinction within the next thirty years. Each plant and animal has a unique niche in its delicate ecosystem; eliminating a few species is tantamount to throwing a wrench in the gearworks of nature.

**Endangered Species in 5-D™ Stereograms** is a book of hope; the animals on these pages can still be preserved. Wolves are being reintroduced into Yellowstone National Park and central Idaho. International treaties seek to end whale-hunting, and reintroduction programs have increased the number of bald eagles in most states. The dedication of caring humans worldwide who give of themselves to assist our ailing animal kin can help reverse this course towards extinction.

While the astounding hidden Multi-Dimensional artwork in this book will amaze you, it would be a terrible shame if these representations of endangered species are all that are left to show our children. Enjoy, share, and cherish this 5-D™ stereogram book and its message of preservation. Help make wildlife conservation a reality by supporting it through direct action in your local and global community.

We need to feel more
to understand others
We need to love more
to be loved back
We need to cry more
to cleanse ourselves
We need to laugh more
to enjoy ourselves —
for we are all one

We need to hear more
and listen to the needs of others
We need to give more
and take less
We need to share more
and own less
We need to look more
and realize that we are not so different
from one another —
for we are all one

We need to care more
and help preserve our animal and plant kin
so that our natural surroundings will survive —
for we are all one

We need to create a world where
every being can
live in harmony —
for we are all one

— Susan Polis Schutz

5-D™ STEREOGRAM image: **"Planet Earth"**

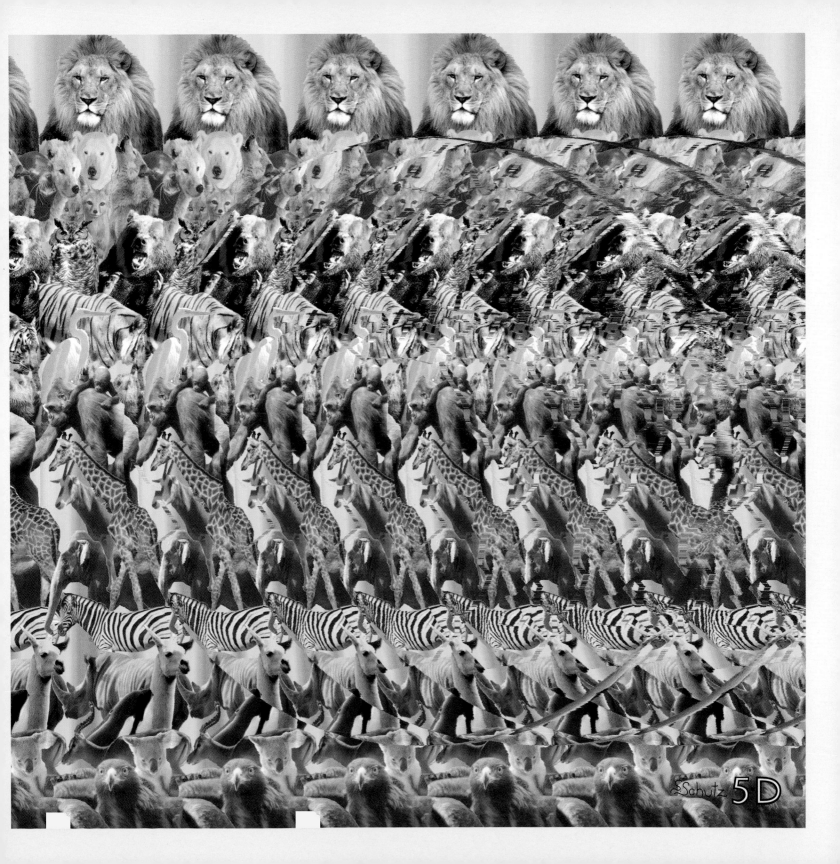

# GRAY WOLF

As many as 750,000 wolves once roamed North America. Native
American tribes admired the wolf for its endurance, intelligence, and
skill in hunting. Wolves live in packs of 8 to 20, and are highly
adaptable and socially evolved. By preying on weak, diseased, and
injured animals, wolves enhance the overall strength of moose,
caribou, and deer populations. Despite their important ecological role,
and posing no threat to humans, wolves have been hunted nearly to
extinction. Their species is endangered. Today in the U.S., the
haunting melody of a howling wolf pack is heard only in a handful of
states.

5-D™ STEREOGRAM image: **"The Song of the Wolf"**

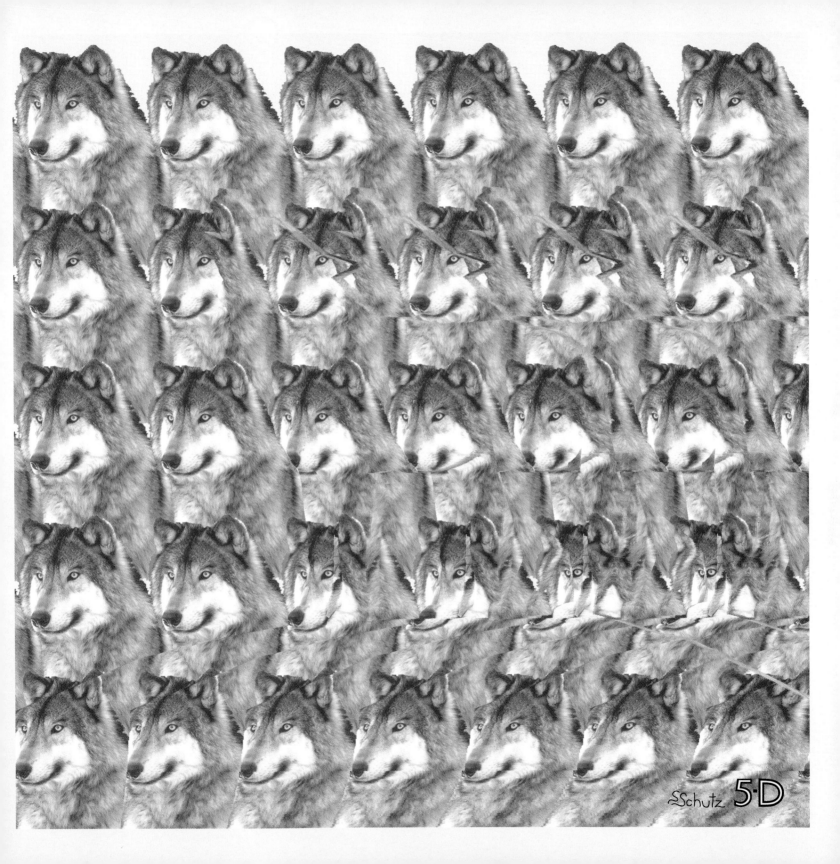

SSchutz 5-D

# Manatee

Manatees, also called sea cows or sea mermaids, are among the gentlest creatures on earth and also the most communicative, with an extensive vocabulary of over a thousand different sounds. They prefer quiet places with abundant aquatic vegetation. Manatees can survive in both salt water and fresh water. They have become endangered because of man's encroachment on their natural habitat. The greatest threat to manatees comes from collisions with powerboats.

5-D™ STEREOGRAM image: **"Swimming Manatee"**

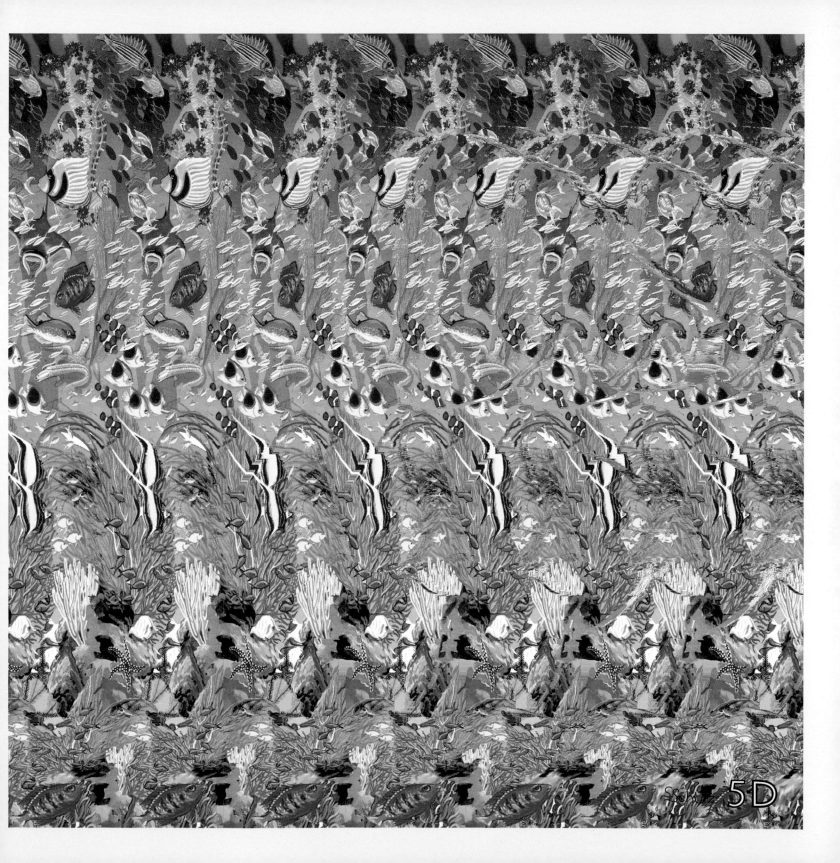

# Vanishing Tiger

Only 5,000 tigers remain to symbolize the last hope for their species' survival in the wild. Eight subspecies of tiger once flourished throughout Asia; today, six are either extinct or critically at risk, and all are endangered. Accelerating deforestation and human encroachment on its habitats increasingly threaten the tiger's future, and position its fate in delicate balance between survival and extinction.

5-D™ STEREOGRAM image: **"On the Brink of Extinction"**

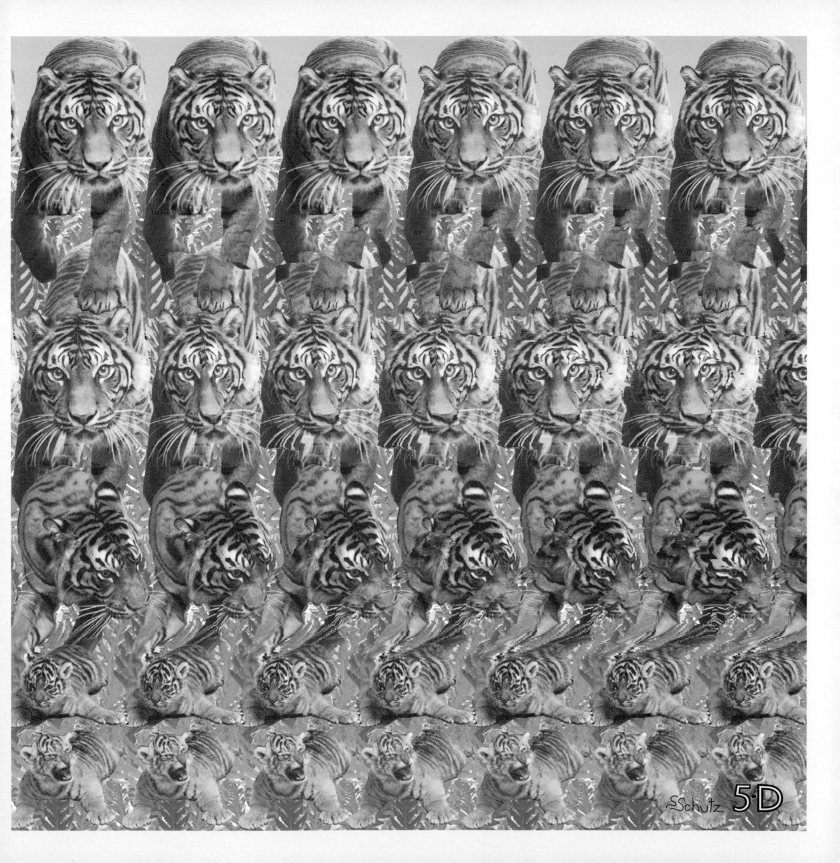

SSchutz 5·D

# Mountain Gorilla

Despite their size and fierce appearance, mountain gorillas are actually gentle and shy, and one of the most intelligent animals on earth. They live at altitudes of up to 13,000 feet in the upland rain forests of central Africa. They coexist peacefully with other species, but humans increasingly endanger their lives and habitat. Fewer than 500 mountain gorillas remain alive today.

5-D™ STEREOGRAM image: **"Silverback"**

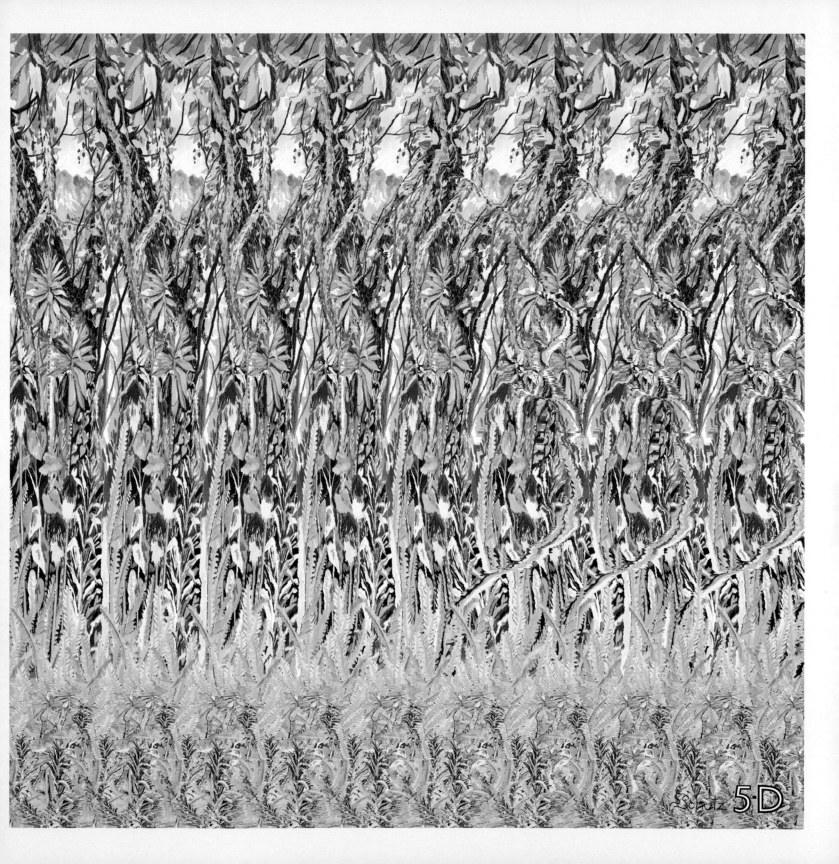

# Endangered Whooping Crane

Swiftly, gracefully, and with wings furiously flapping, a flock of whooping cranes spirals high up into the sky, off on its annual migration from Canada to the Texas coast. With luck, most of them will make it. The number of these rare and beautiful birds began to decline in the 19th century. In 1941, only 15 birds were known to exist. Publicity about their plight and massive public support led to the creation of conservation groups, protection of breeding and wintering grounds in the U.S. and Canada, and laws prohibiting hunters from shooting them. A principal example of conservation efforts at their best, about 265 whooping cranes exist in North America today.

5-D™ STEREOGRAM image: **"Cranes in Flight"**

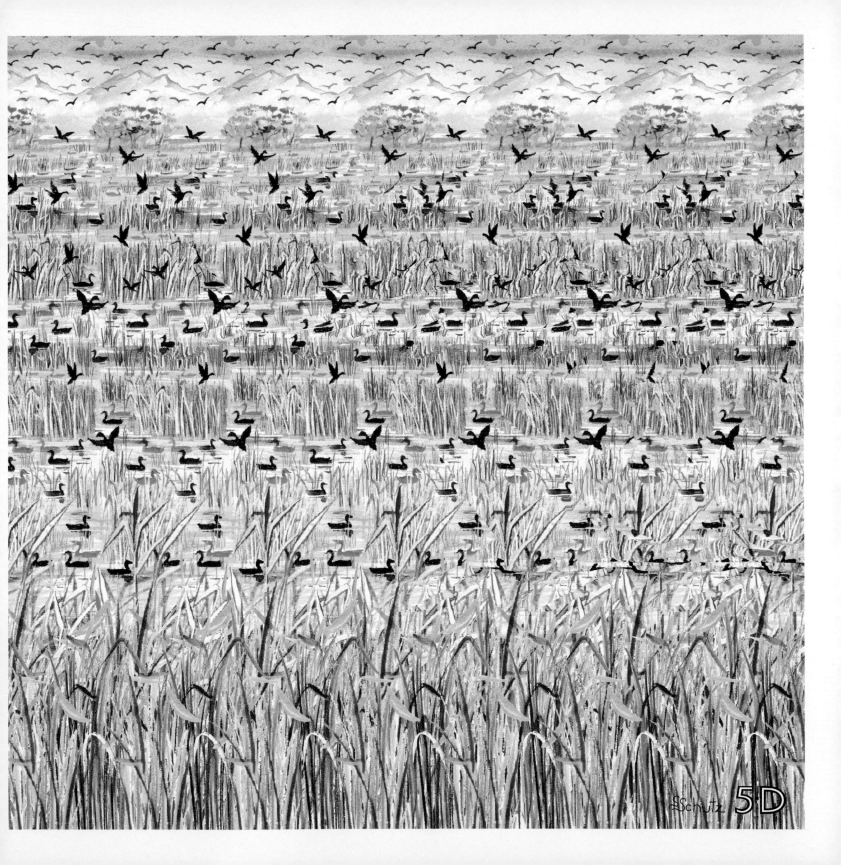

# RHINOCEROS

Rhinoceroses have roamed the earth since prehistoric times. They are solitary animals who rarely fight among themselves and whom most other animals actively avoid. Their horns, which some cultures believe have medicinal value, are their most distinctive feature. Prized among wild-game trophy hunters for the danger involved in hunting them and by poachers for the price their horns bring, the rhinoceros is now endangered. Today, only five of what used to be dozens of species remain: three in Asia and two in Africa.

5-D™ STEREOGRAM image: **"Rhinoceros"**

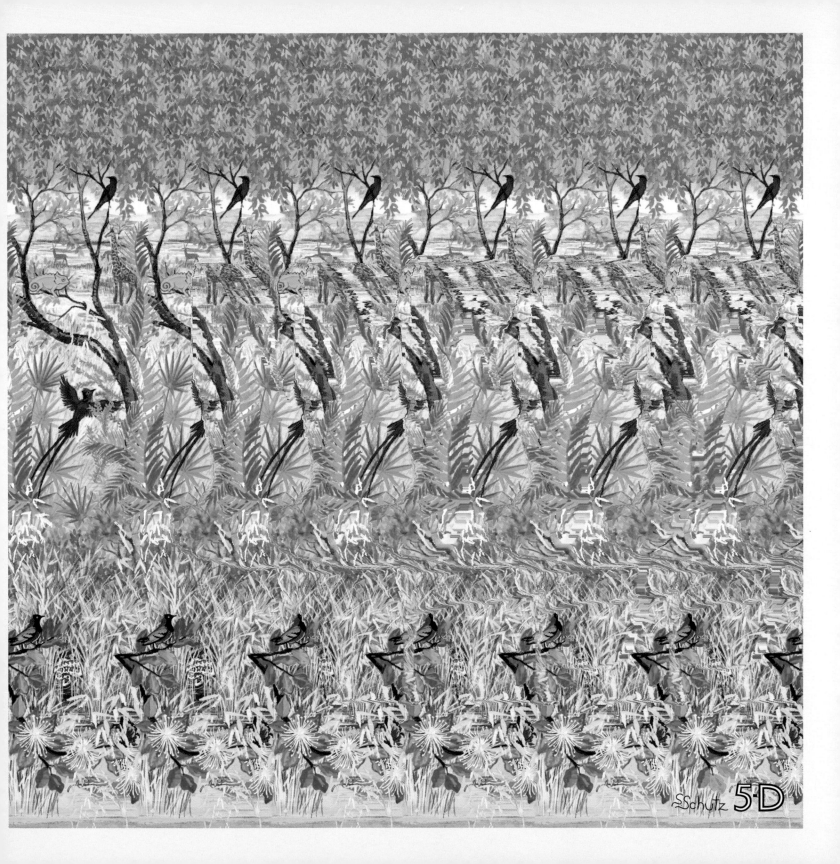

Schutz 5·D

# Cheetah

Cheetahs are easily tamed and were actually used by the maharajahs in India to hunt antelope. The cheetah is able to attain speeds of up to 70 miles per hour over short distances. In a manner closer to dogs than other cats, the cheetah runs its prey down instead of taking it by surprise. Hunted for their pelts, the number of cheetahs has declined rapidly. Confined mostly to central and eastern Africa, few — if any — cheetahs remain alive in Asia.

5-D™ STEREOGRAM image: **"Cheetah Pouncing"**

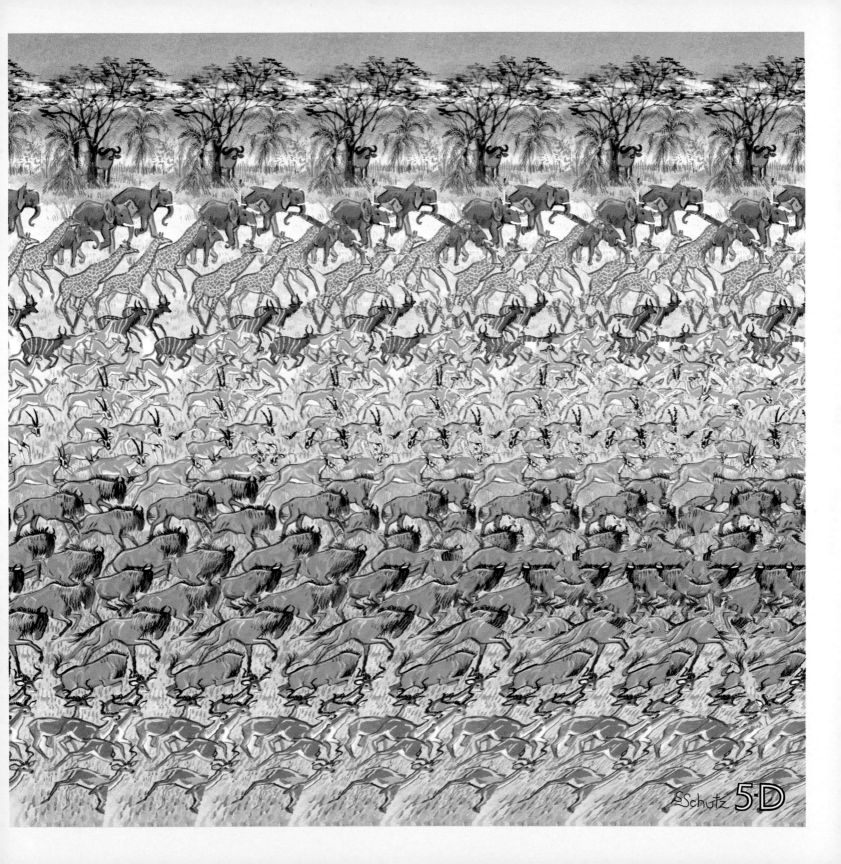

# Endangered Elephant

The ground shakes, a cloud of dust erupts, and a loud trumpet sound can be heard, as the world's largest living land animal bursts through the forest, its head and trunk raised, ears extended. Now imagine that same elephant, only this time it's lying on the ground, its ivory tusks gone, the victim of a poacher. Or witness the elephant, trained to clear trees from the very forest where it makes its home. A 1990 international trade ban on ivory has significantly reduced the incidence of poaching. Recent counts reveal that about 600,000 African elephants and as many as 44,000 Asian elephants remain at large. The dilemma now… how to accommodate exploding human development in the elephants' native habitats and still leave the extensive space necessary for them to continue to exist in the wild.

5-D™ STEREOGRAM image: **"Mother Elephant with Calf"**

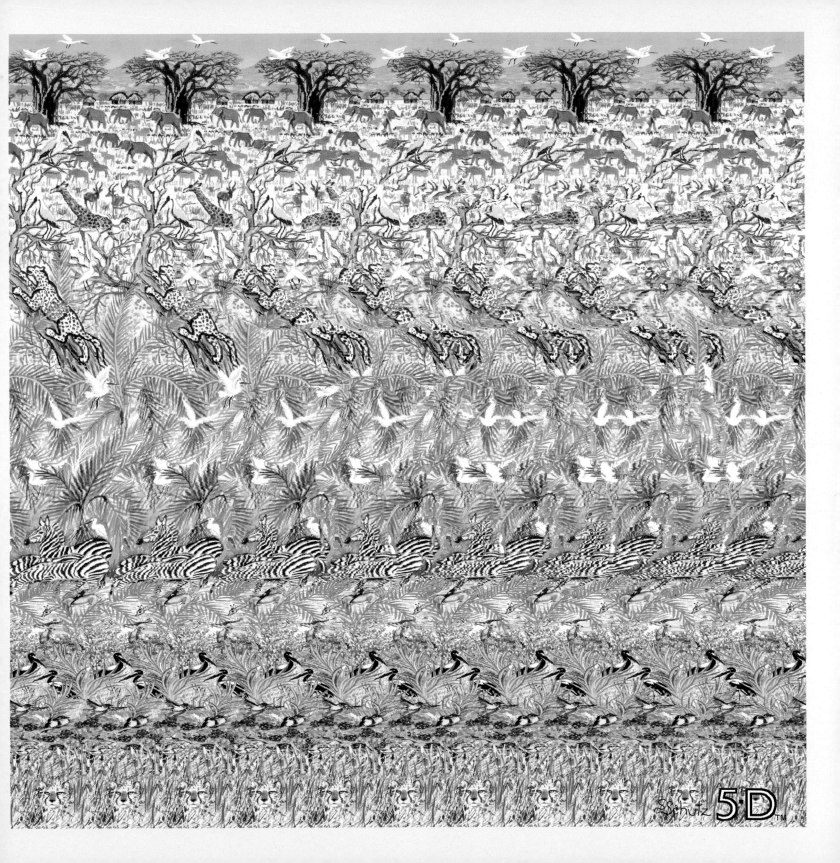

5D™

# SNOW LEOPARD

Also known as the ounce, the snow leopard has been hunted to the
brink of extinction for its fur. During the summer, the snow leopard
lives at altitudes as high as 13,000 feet in the mountains of central
Asia and the Indian subcontinent. In the coldest months of winter, it
will descend to valleys as low as 6,000 feet. The snow leopard hunts
primarily at night and preys on animals such as marmots and wild
sheep.

5-D™ STEREOGRAM image: "Leopard Leaping"

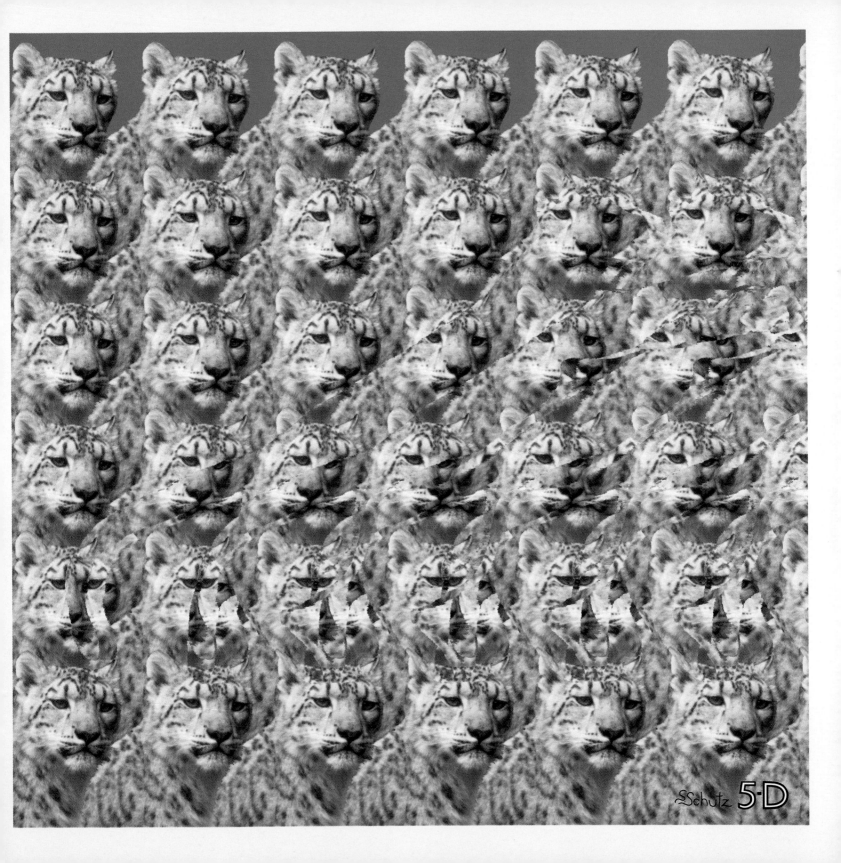

# Vanishing Bald Eagle

If human beings had the bald eagle's eyesight, they could read the text of a newspaper from 300 feet away! Yet people have been mostly blind to the harm they've caused this magnificent raptor in the 20th century. In the mid-1970s, fewer than 3,000 bald eagles existed in the continental U.S. Today, thanks to pesticide bans and conservation efforts, the bald eagle has made a gradual comeback in many states. However, many challenges still threaten its lasting survival.

5-D™ STEREOGRAM image: **"Bald Eagle over Grand Canyon"**

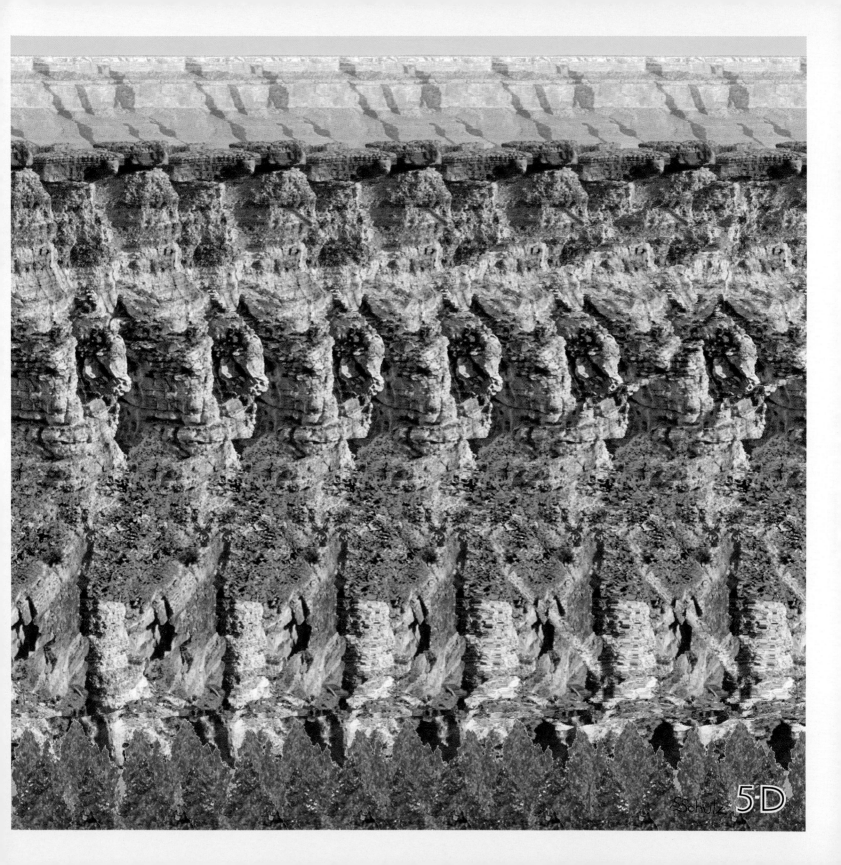

# HUMPBACK WHALE

Humpback whales are poets of the deep. Their songs, which can be heard by other whales hundreds of miles away, actually have repeating patterns similar to rhymes in our poetry. Scientists speculate these rhymes might help the whales remember what comes next in their songs. Despite its name, the humpback whale has no hump. Nor does it have any teeth; instead, its mouth is filled with hundreds of thin plates, called baleen, which is a material similar to human fingernails. The whale uses its baleen to strain plankton out of the water for food. Despite a 1966 ban on the hunting of these whales, they currently number only in the thousands, down from hundreds of thousands before they were hunted by man.

5-D™ STEREOGRAM image: **"Humpback Whale Diving"**

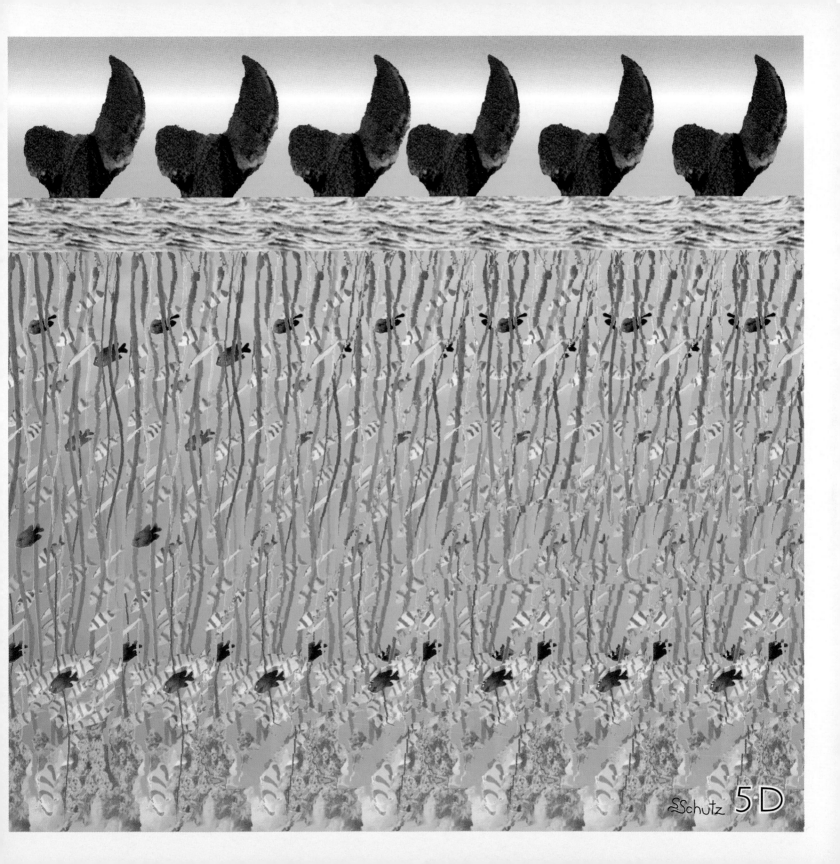

# VANISHING PANDA

The panda is one of the rarest and most endangered mammals on
earth. Fewer than 800 survive in their native habitat, which is located
in the cool bamboo forests in the mountains of southwestern China
and eastern Tibet. The panda has become an international symbol for
all endangered species, but despite massive conservation efforts, its
own future in the wild remains in jeopardy.

5-D™ STEREOGRAM image: **"Giant Panda"**

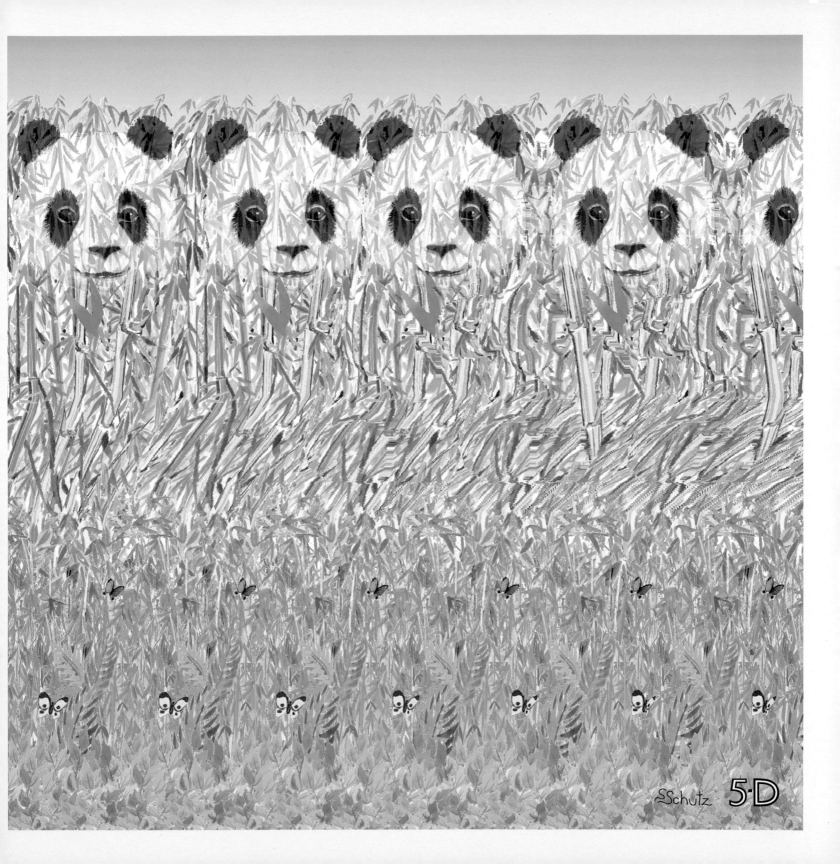

# Seeing in Stereo

## Stephen Schutz, Ph.D., Takes the Art of the Stereogram to a New Aesthetic Level

Recent improvements in computer technology have enabled the famous artist (and physicist) Stephen Schutz to pass a new threshold of innovation and liberate art from its prior two-dimensional limitations. "Spectacular!" says Leonard Nimoy about 5-D™ stereograms. "Beautiful and often dazzling works of art," says Dick Kreck of *The Denver Post*.

5-D™ stereograms, Stephen Schutz's most recent artistic creation, effectively establish a genre of Multi-Dimensional art. Stereograms had their origins in 1960 when Bela Julesz developed the "random-dot stereogram" as a tool to study perceptual psychology. For the past thirty years, primitive random-dot stereograms have relied on repetitive textures to disguise hidden three-dimensional images.

Stephen Schutz's 5-D™ stereograms have successfully replaced random-dot textures with incredible artwork, which makes 5-D™ stereograms "dimensional dynamite," in the words of David Hutchison of the National Stereoscopic Association. The full-color base-art foregrounds (what everyone sees on the surface) are attractions in and of themselves. When this foreground is dramatically supplemented by a hidden image that relates and interacts with it, the exquisite result comes alive as wolves leap off the page and stars hang in a multi-layered sky. Stephen Schutz's accomplishment is a testimony to what can happen when the creative envelope of art is expanded and enhanced by the cutting edge of technology.

"Over the past few years, random-dot stereograms have been popping up all over the place. Unfortunately, most are very boring," notes 3-D collector and writer for *Stereo World* magazine, Sheldon Aronowitz. "This has all changed with the release of the Blue Mountain Arts 5-D™ stereograms developed by Dr. Stephen Schutz. In their flat format, they are works of art in their own right. When viewed in three dimensions, you will be amazed and delighted with the clarity and ingenious blending of theme. No more patterns of endless dots."

# About the Artist and Author

Stephen Schutz is an artist and a physicist, a rare combination of talents emanating from the mind and heart. Enraptured at an early age with beauty and aesthetic form, Stephen pursued the paths of science and art simultaneously. He graduated from the famous High School of Music and Art in New York, and studied physics at M.I.T. and Princeton University, where he received a Ph.D. in theoretical physics in 1970. While pursuing advanced scientific learning, Stephen continued to develop his artistic abilities at the Museum of Fine Arts in Boston.

During college, Stephen met and fell in love with the woman who was to become his equal loving partner in marriage, family, and art. In 1969, Susan Polis Schutz and Stephen Schutz moved to the mountains of Colorado where Susan was a freelance writer and Stephen researched solar energy at a government research laboratory. On the weekends, they began experimenting with printing Susan's poems surrounded by Stephen's art on posters that they silk-screened in their basement. From the very start, their love of life and for one another touched a receptive chord in people everywhere. The public's discovery of the creative collaboration of Susan Polis Schutz and Stephen Schutz set the stage for a world-wide love affair with their works. Frequent visitors to the bestseller lists, Susan and Stephen's books and poetry cards have touched the hearts of over 200 million people, and their works have been translated into many languages.

Because Stephen is an artist, computer whiz, and innovator, there is no one better suited to take the art of the stereogram to its next level. Combine that with the fact that it would be difficult to discover a poet with a more significant following than Susan Polis Schutz, who *TIME* magazine referred to as "the reigning star… in high emotion." Together, Susan and Stephen Schutz's most recent books, featuring Susan's poetic messages and Stephen's 5-D™ stereograms, are just the latest in a series of beautiful contributions the couple has made over the past 25 years.

# Hidden 5-D™ Stereogram Images

Planet Earth

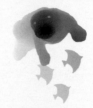
The Song of the Wolf
(Gray Wolf)

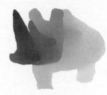
Swimming Manatee

On the Brink of Extinction
(Sumatran Tiger Cub)

Silverback
(Mountain Gorilla)

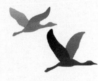
Cranes in Flight
(Whooping Cranes)

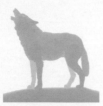
Rhinoceros

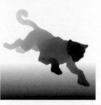
Cheetah Pouncing

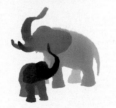
Mother Elephant with Calf

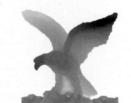
Leopard Leaping

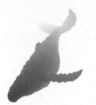
Bald Eagle over Grand Canyon

Humpback Whale Diving

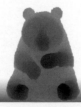
Giant Panda